Frances Lincoln Limited
74–77 White Lion Street
London N1 9PF
www.franceslincoln.com

The Royal Horticultural Society Pocket Floral Colouring Book

A catalogue record for this book is available from the British Library

ISBN: 978-0-7112-3868-8
Printed and bound in China

1 3 5 7 9 8 6 4 2

Royal
Horticultural
Society

POCKET FLORAL
COLOURING
BOOK

F

FRANCES
LINCOLN

Royal
Horticultural
Society

Pocket Floral Colouring Book

The floral illustrations in this book are from the world-famous
RHS Lindley Library, which brings together a vast range of
historical gardening illustrations of rare and unusual cultivars.

Each illustration has inspired a black and white floral pattern for
you to colour. Use pencils, pastels, pens or paints to create colour
and texture to these pages.

Take inspiration from the vibrant colours in the floral images, or let
your imagination run riot and dream up colours of your own design.

Paeonia peregrina: unsigned hand-coloured engraving from H.G.L Reichenbach et al., *Icones florae Germanicae et Helveticae*, vol. 4 (1840).

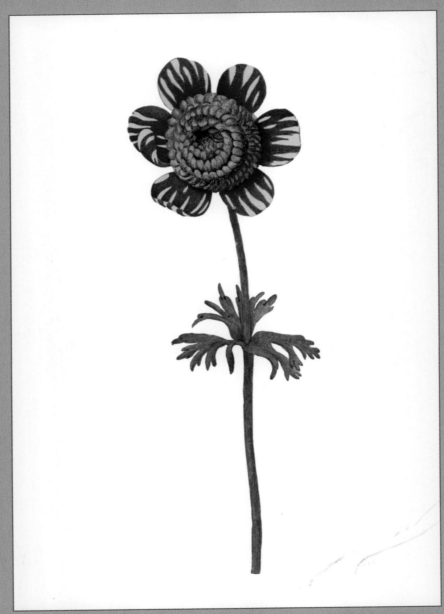

An elaborate but unnamed cultivar of *Anemone coronaria*: watercolour on vellum by an anonymous Italian artist, 17th or early 18th century.

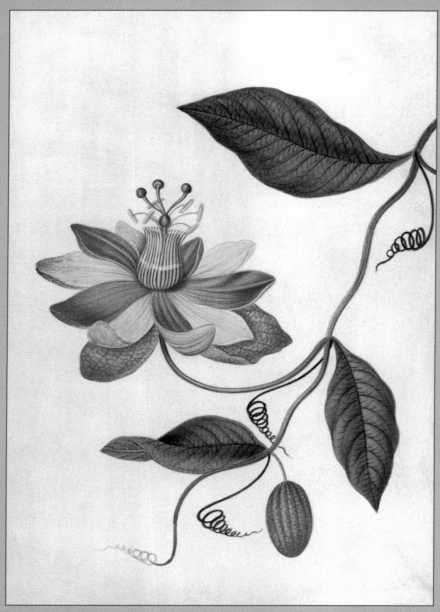

'Monier's Passion Flower': watercolour on vellum by James Bolton (c.1735–99). It resembles *Passiflora × alatocaerulea* (now *P. × belotii*), which was named in 1824; could it have been an early hybrid?

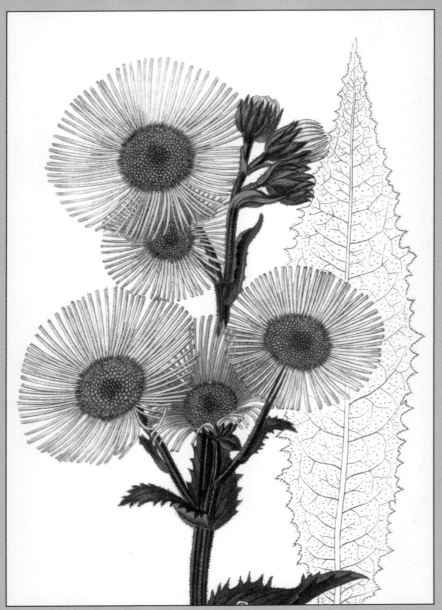

Leptostelma maxima (now *Erigeron maximus*): hand-coloured engraving after Edwin Dalton Smith from Sweet's *British Flower Garden*, second series, published March 1830.

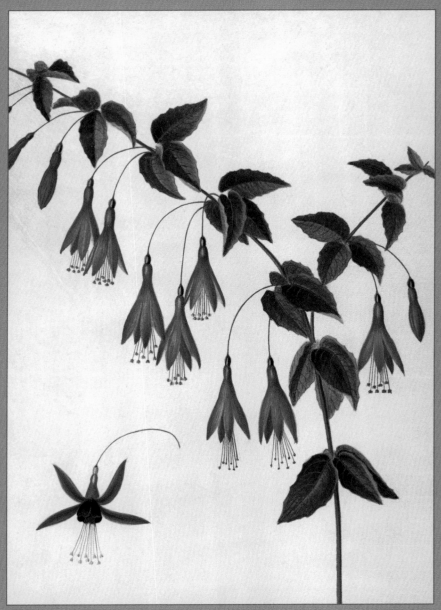

Fuchsia coccinea: watercolour on vellum by James Bolton (c.1735–99).

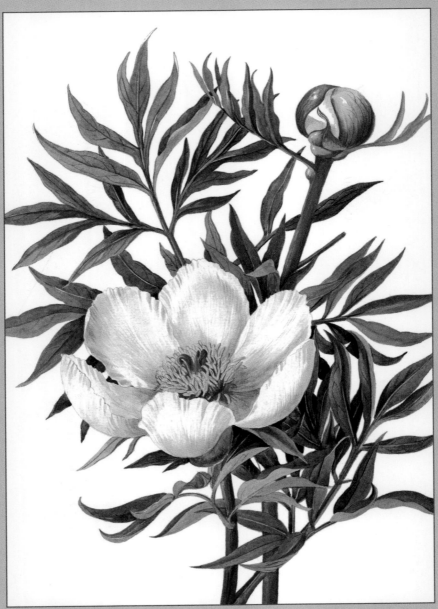

Paeonia clusii: coloured drawing by Lilian Snelling, May 1931, for a plate in Sir Frederick Stern's *Study of the Genus Paeonia* (1946).

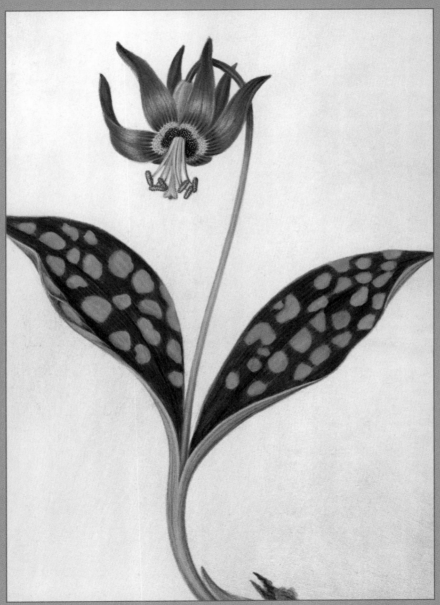

A dog's-tooth violet, *Erythronium dens-canis*: watercolour on vellum by James Bolton (c.1735–99).

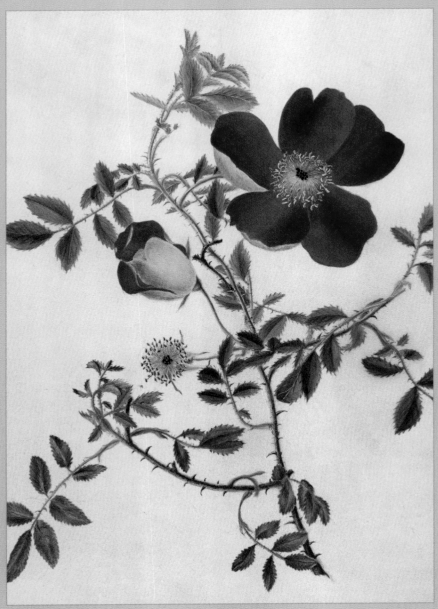

Rosa foetida 'Bicolor': watercolour on vellum by Emma Smith (fl.1780s–1845).

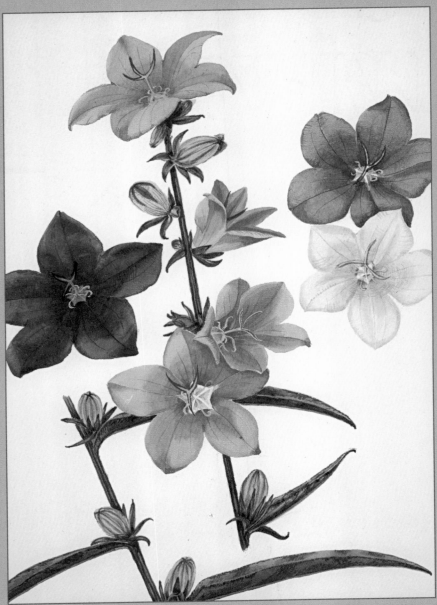

Campanula latiloba 'Hidcote Amethyst', *Campanula latiloba* 'Highcliffe Variety' and *Campanula latiloba* 'Alba' by Graham Stuart Thomas. First published in *Gardens of the National Trust* (1979).

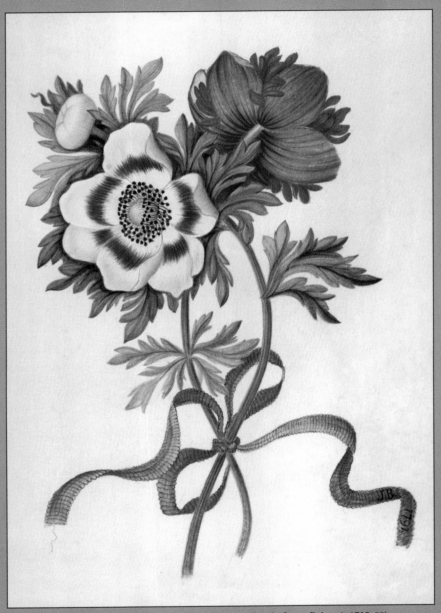

'Anemones', cultivars of *Anemone coronaria*: watercolour on vellum by James Bolton (c.1735–99), dated 1791.

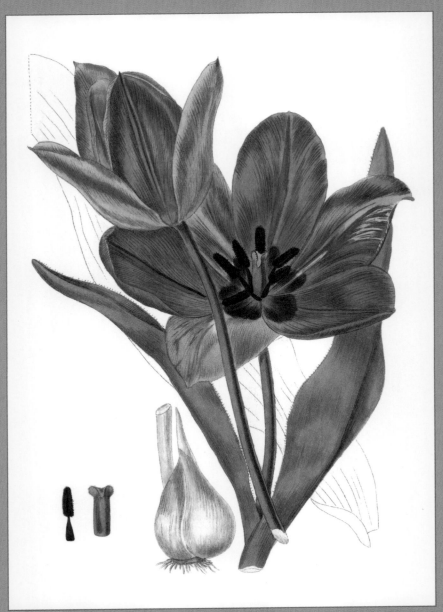

Tulipa maleolens: hand-coloured engraving after Edwin Dalton Smith from Sweet's *British Flower Garden*, second series, published August 1832.

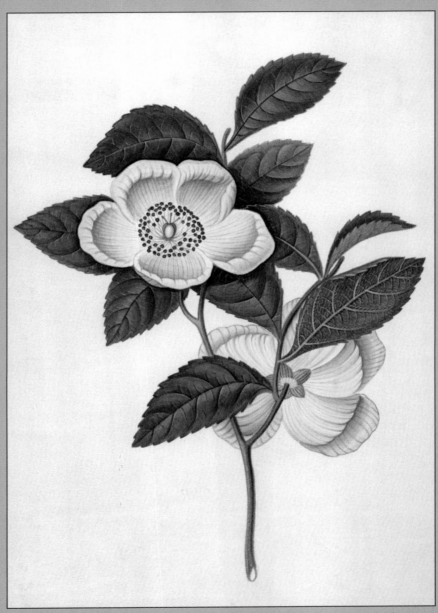

The silky stewartia, *Stewartia malacodendron*: watercolour on vellum by James Bolton (c.1735–99).

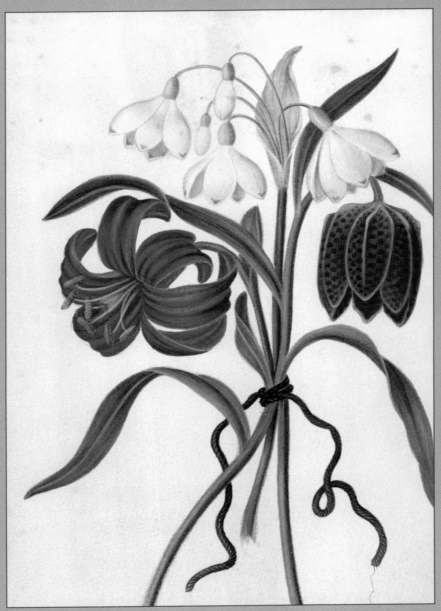

'Scarlet Martagon, Cluster Snowdrop, Purple Fritillaria': watercolour on vellum by James Bolton
(c.1735–99) depicting *Lilium martagon*, *Galanthus nivalis* and *Fritillaria meleagris*.

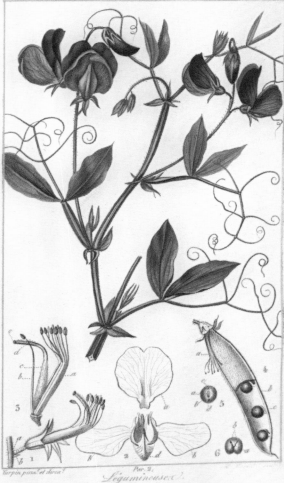

A sweet pea, *Lathyrus odoratus*: coloured illustration on vellum by Pierre Jean François Turpin (1775–1840) from *Leçons de Flore* (1820).

Lilium bulbiferum: watercolour on vellum by an anonymous Italian artist, 17th or early 18th century.

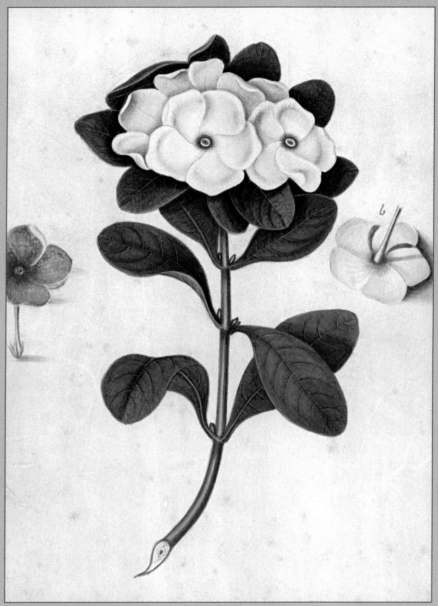

'*Vinca rosea*, White Madagascar Periwinkle': watercolour on vellum by James Bolton (c.1735–99).

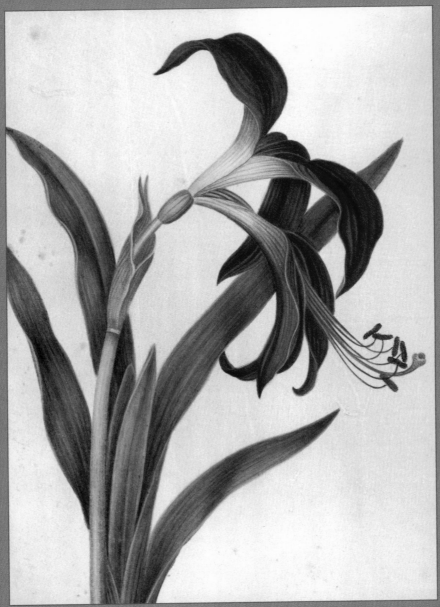

'Jacobean lily', *Sprekelia formosissima*: watercolour on vellum by James Bolton (c.1735–99).

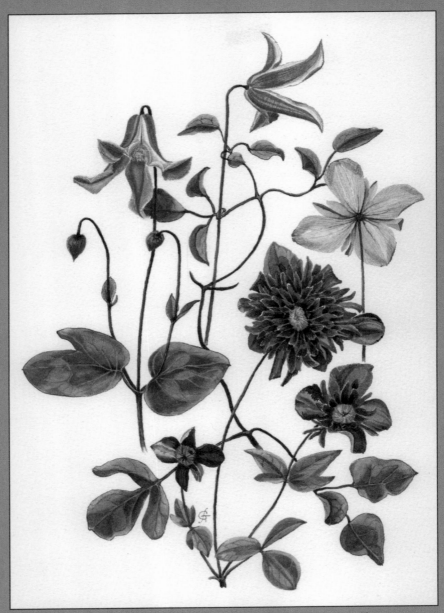

Clematis viticella 'Purpurea Plena Elegans' and *Clematis* 'Etoile Rose' by Graham Stuart Thomas.
First published in *Three Gardens* (1983).

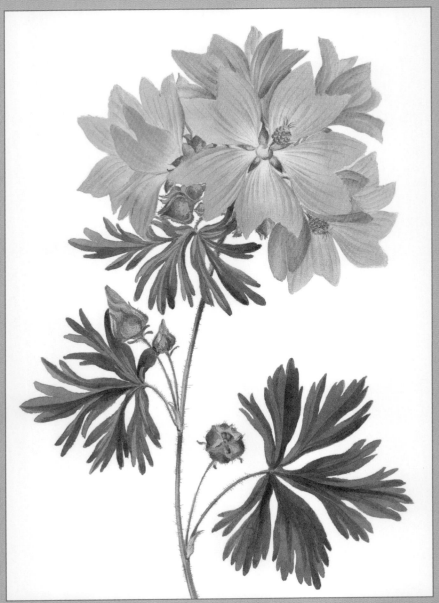

Malva moschata: watercolour on paper by Lydia Penrose, from the album 'Flora Devoniensis'.

Two roses, 'Auguste Gervais' and 'Alexandre Girault' by Graham Stuart Thomas. First published in *Climbing Roses Old and New* (1965).

Crocus olivieri, *Prunus tenella*, *Galanthus nivalis* and *Omphalodes verna*: watercolour by
Caroline Maria Applebee, c.1814.

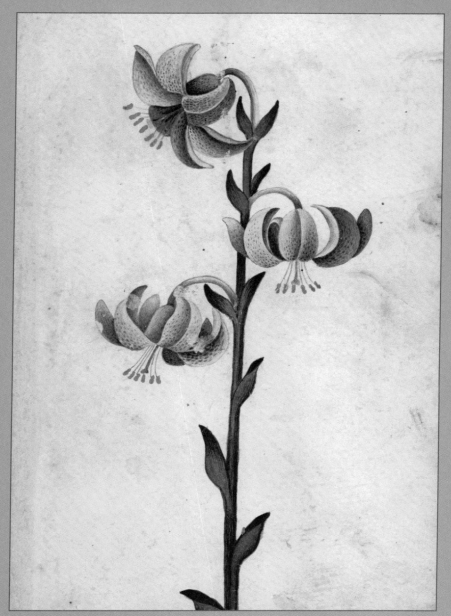

Lilium martagon: watercolour on vellum by an anonymous Italian artist, 17th or early 18th century.

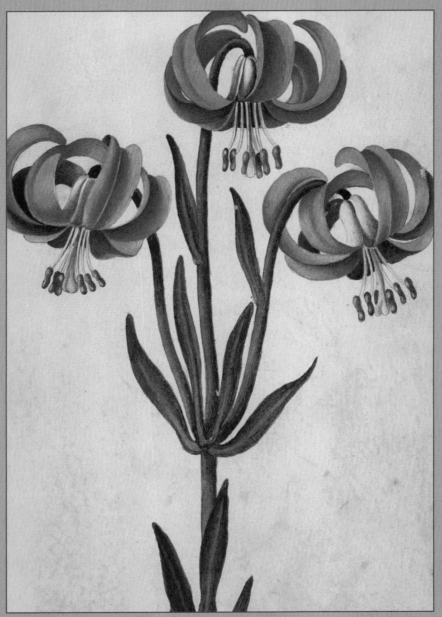

A turban lily, *Lilium pomponium*: watercolour on vellum by an anonymous Italian artist, 17th or early 18th century.

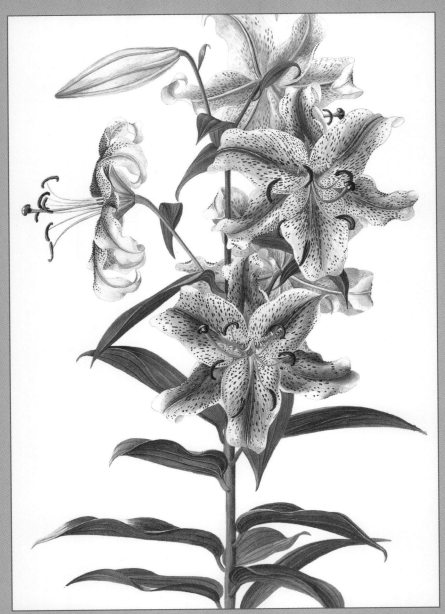

Lilium × parkmanni: coloured drawing, undated, by Lilian Snelling.

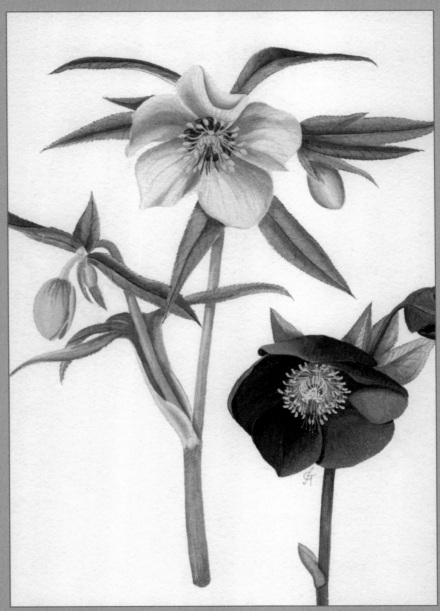

Helleborus 'Bowles's Yellow' and *Helleborus atrorubens* by Graham Stuart Thomas. First published in
Colour in the Winter Garden (1967).

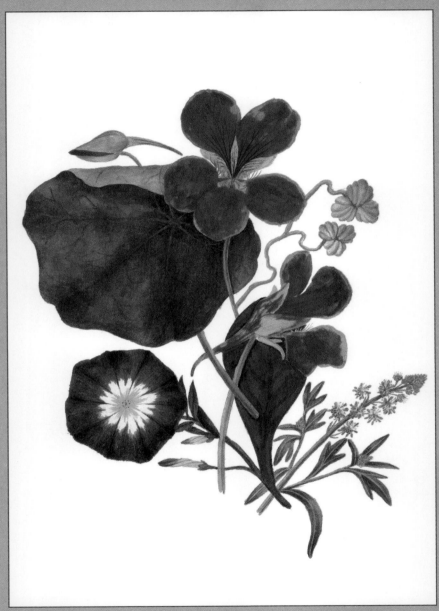

Convolvulus tricolor, *Tropaeolum majus* and *Reseda odorata*: watercolour by Caroline Maria
Applebee, 1810.

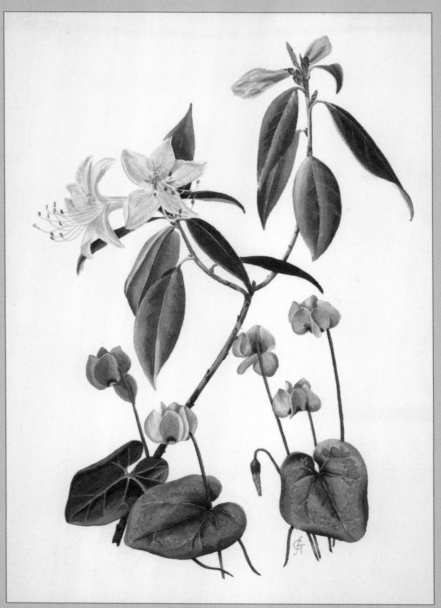

Rhododendron lutescens with the West Asian species *Cyclamen coum* by Graham Stuart Thomas.
First published in *Colour in the Winter Garden* (1967).

Pink 'Davey's Juliet': hand-coloured engraving after Edwin Dalton Smith from Sweet's *Florist's Guide*,
published August 1827.

Callistephus chinensis and *Coreopsis tinctoria*: watercolour by Caroline Maria Applebee, c.1814.

Three *Crocosmia* cultivars or montbretias: from the top, 'Star of the East', 'Vesuvius' and 'Queen of Spain' by Graham Stuart Thomas. First published in *Three Gardens* (1983).

Magnolia × loebneri 'Leonard Messel' and *Forsythia suspensa* 'Nymans' by Graham Stuart Thomas.
First published in *Gardens of the National Trust* (1979).

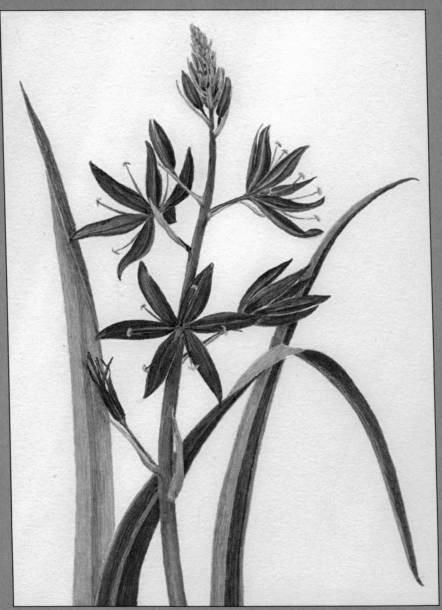

Camassia leichtlinii subsp. *suksdorfii* 'Lady Eve Price' by Graham Stuart Thomas. First published in *The Garden Throughout the Year* (2002).

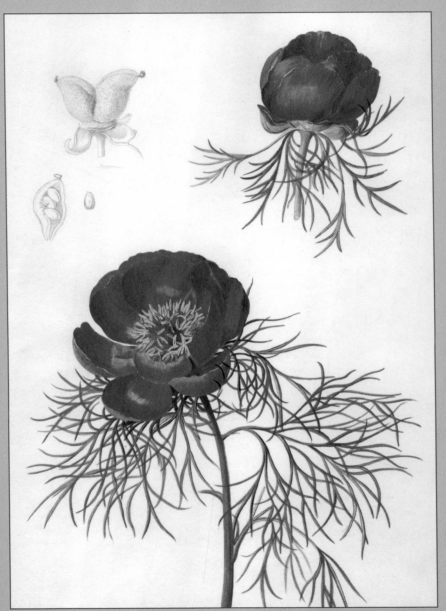

Paeonia tenuifolia: coloured drawing, dated May 1931, by Lilian Snelling for a plate in Sir Frederick Stern's *Study of the Genus Paeonia* (1946).

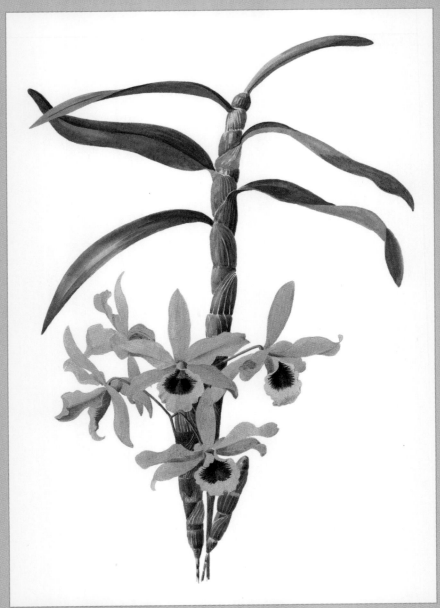

Dendrobium thwaitesii: coloured drawing, dated April 1915, by Lilian Snelling.

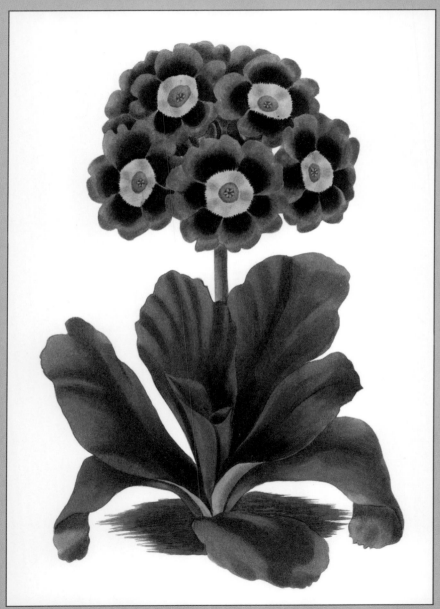

Auricula 'Howe's Venus': hand-coloured engraving after Edwin Dalton Smith from Sweet's *Florist's Guide*,
published March 1829.

Crocus suaveolens: hand-coloured engraving after J. T. Hart from Sweet's *British Flower Garden*, second series, published September 1836.

Vaccinium sp: coloured drawing, dated May 1929, by Lilian Snelling.

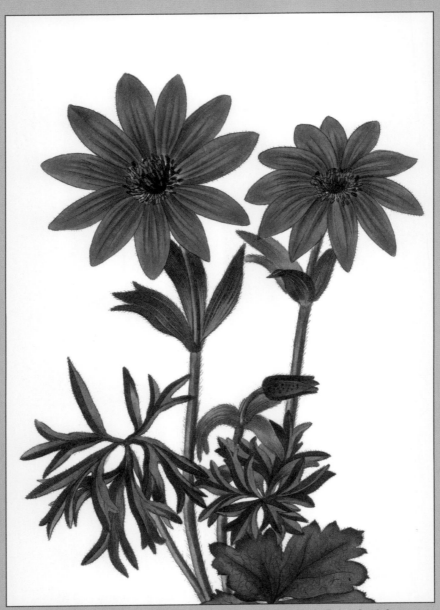

Anemone stellata (now *Anemone hortensis*): hand-coloured engraving after Edwin Dalton Smith from Sweet's *British Flower Garden*, published June 1825.

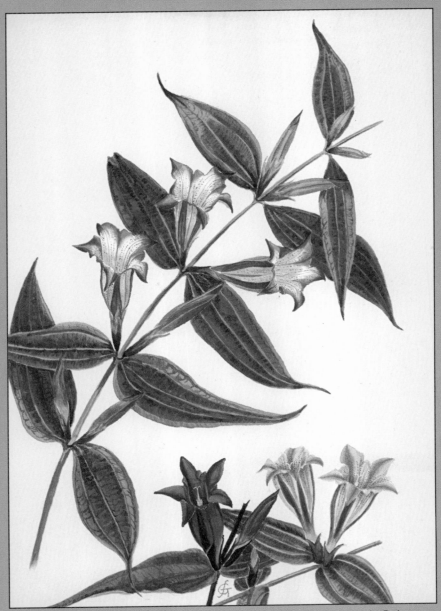

Gentiana asclepiadea 'Knightshayes', together with a pale blue form shown for comparison, by Graham Stuart Thomas. First published in *Gardens of the National Trust* (1979).

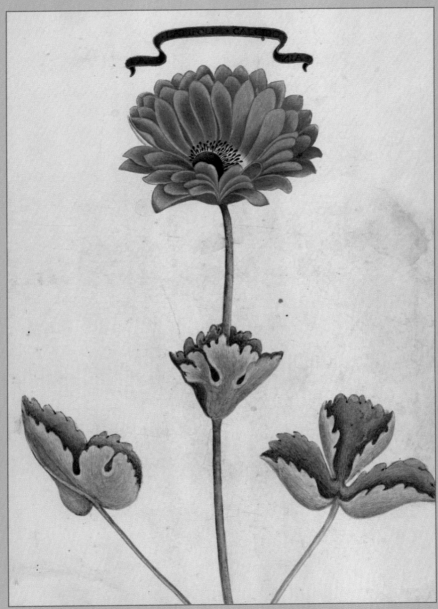

'*Anemone latifolia calcidonia* [sic = *chalcedonica*]', a doubled form of *Anemone coronaria*: watercolour on vellum by an anonymous Italian artist, 17th or early 18th century.

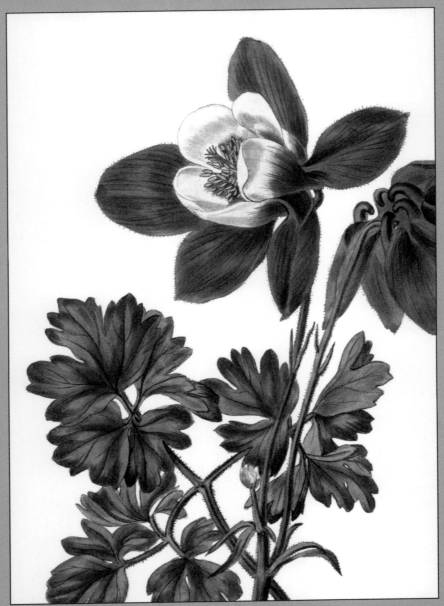

Aquilegia glandulosa: hand-coloured engraving after Edwin Dalton Smith from Sweet's *British Flower Garden*, second series, published July 1830.

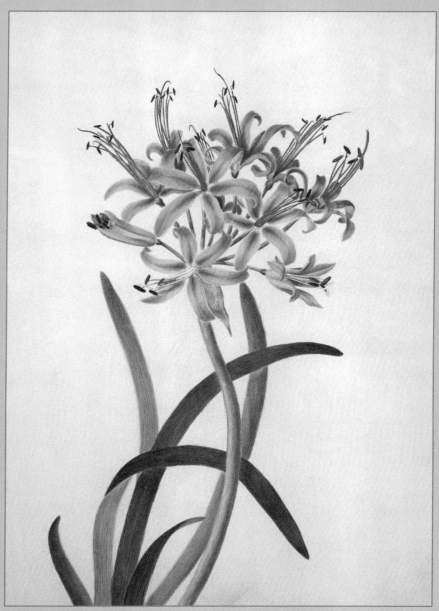

The Guernsey lily, *Nerine sarniensis*: watercolour on vellum by Eliza Smith (fl.1780s).

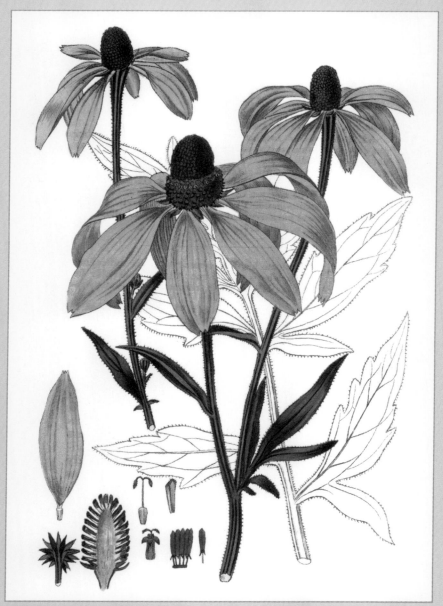

Rudbeckia pinnata (now *Ratibida pinnata*): hand-coloured engraving after Edwin Dalton Smith from
Sweet's *British Flower Garden*, published March 1826.

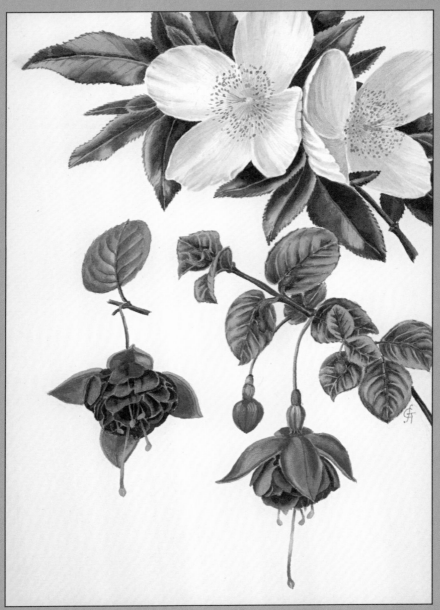

Eucryphia × nymansensis and *Fuchsia* 'Mount Stewart' by Graham Stuart Thomas. First published in *Gardens of the National Trust* (1979).

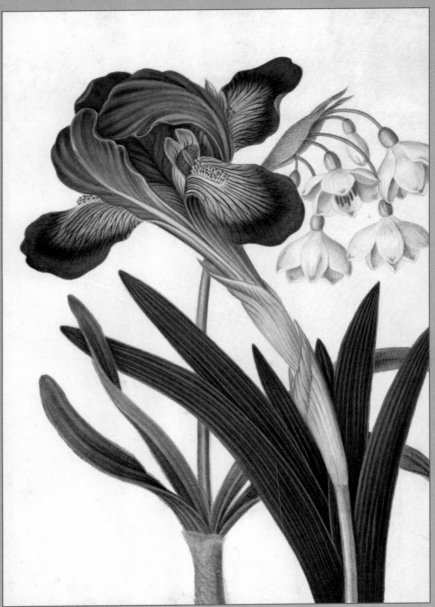

'Painted iris and summer snowdrop': watercolour on vellum by James Bolton (c.1735–99), depicting an extravagantly patterned *Iris persica* and *Leucojum aestivum*.